Children's Art Book

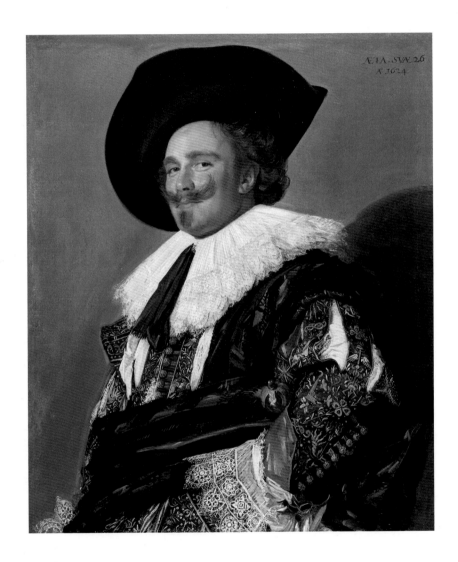

By Emmajane Avery

Illustrations by Robin Ollington and Albany Wiseman

Foreword

A young person's first experience of art can change their lives forever. So many people remember how they were only eight, or ten or twelve, when they first encountered a suit of armour, or Frans Hals's *Laughing Cavalier* or Fragonard's *The Swing* in the Wallace Collection. They have never, ever, forgotten that brilliant moment. They were inspired by the scale and gleam of the metal clothes, or the smiley twinkle and symbolic costume of the Cavalier, or the sheer prettiness of the naughty girl in her pink dress playing on a swing.

To enjoy such works of art requires only your eyes! Looking and seeing is everything when you are young. Then gradually as the years go by you still come back to these same works of art and see them through different eyes: those that are now intrigued by the history of the tournament and battle, of love and marriage, or of the racy life of the French Rococo. This is what makes great art so human, so wonderful and so all-embracing: it is for everyone, at all times in our lives, regardless of who we are or where we come from or where we are going to. I so hope children and adults alike will love this book and, if you have not already done so, it will encourage you to come racing to the Wallace Collection to see the works of art for yourselves.

The Wallace Collection Children's Art Book was conceived and written by Emmajane Avery, the superb Head of Learning at the Wallace Collection. She has always longed to be able to introduce young people to art through the variety and wonders of the Wallace Collection, and this has now been made possible by the great kindness of Elizabeth Cayzer of the Elizabeth Cayzer Charitable Trust. I am hugely grateful to them both for their creativity and vision, and I hope you will be too!

DAME ROSALIND SAVILL

DIRECTOR, THE WALLACE COLLECTION

Contents

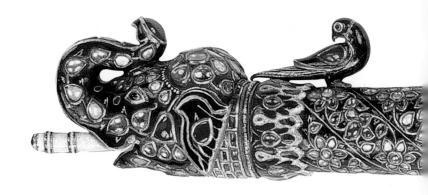

Welcome to
The Wallace Collection!

The wonderful objects that you will see in this book are all kept at the Wallace Collection, a house full of treasures in central London.

THE BILLIARD ROOM

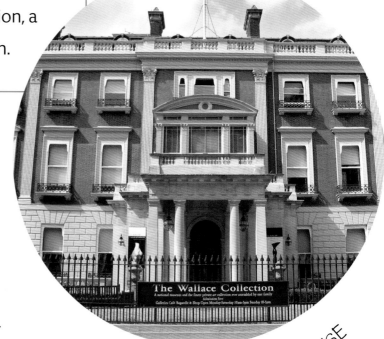

THE HOUSE

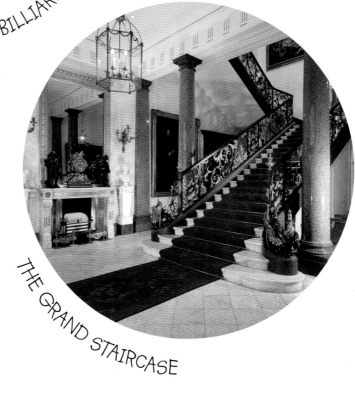

THE GRAND STAIRCASE

The Wallace Collection is now a museum but it was once the home of Sir Richard Wallace. He lived here during Victorian times and owned everything you will see in this book, such as …

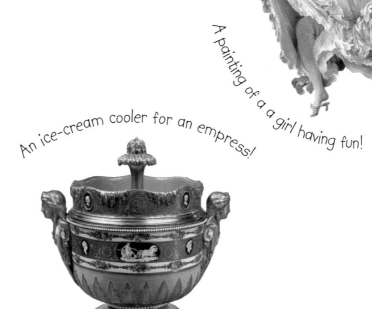
A painting of a a girl having fun!

Armour for a Knight!

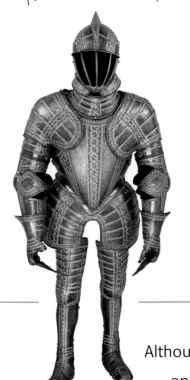

An ice-cream cooler for an empress!

Although Sir Richard owned all these works of art,
only some of them were bought by him …

Some were bought by his father
some were bought by his grandfather
some were bought by his great-grandfather
and some even by his great-great-grandfather.

What an amazing family!

Follow Sir Richard through the pages of this book to find out more about all kinds of artworks – and a bit more about him!

King Louis XV

This painting shows Louis XV, who became King of France around 300 years ago. It is a grand portrait, showing the King at his best.

Kings and queens have certain objects that they carry or wear to show that they are the ruler.

Can you find the following things in the painting?

- **Red velvet:** a rich, heavy fabric in a regal colour
- Ermine robes, made from a special type of fur
- Crown
- Sceptre
- Throne
- Pointer
- The fleur de lys, the special sign of the King of France

All of these have specific meanings and can only belong to the king or queen. Other wealthy people can wear grand clothes made of expensive material, but only the king or queen can wear ermine or a crown or hold the sceptre. If you see someone with these things you know they are royalty.

Did you know?

Louis became King of France when he was 5 years old. Do you think he could rule the country when he was that age? When a king dies, if the next in line is too young then someone rules in their place until they are old enough. In this case it was Louis's uncle, Philippe.

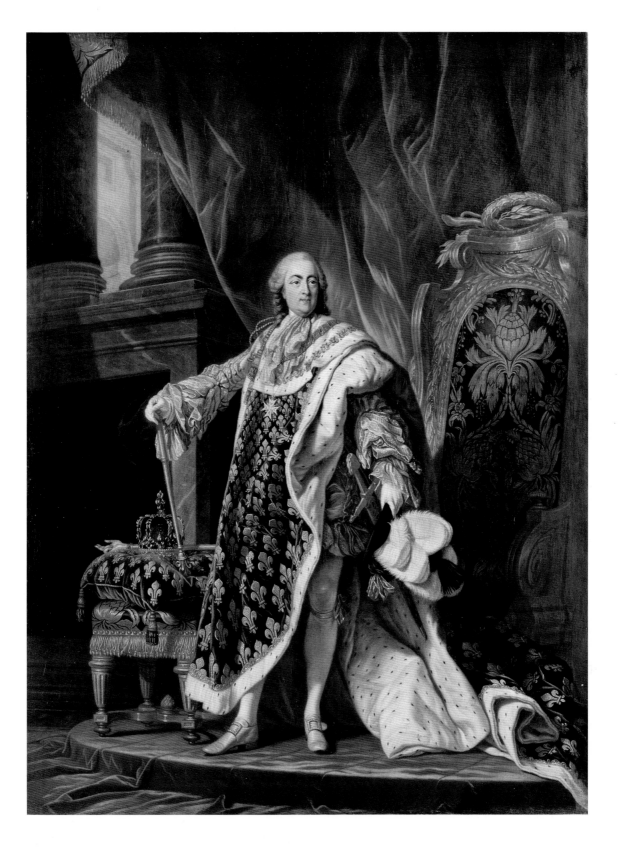

Studio of Louis-Michel Van Loo
Louis XV
Paris, 18th century (*c.* 1760)

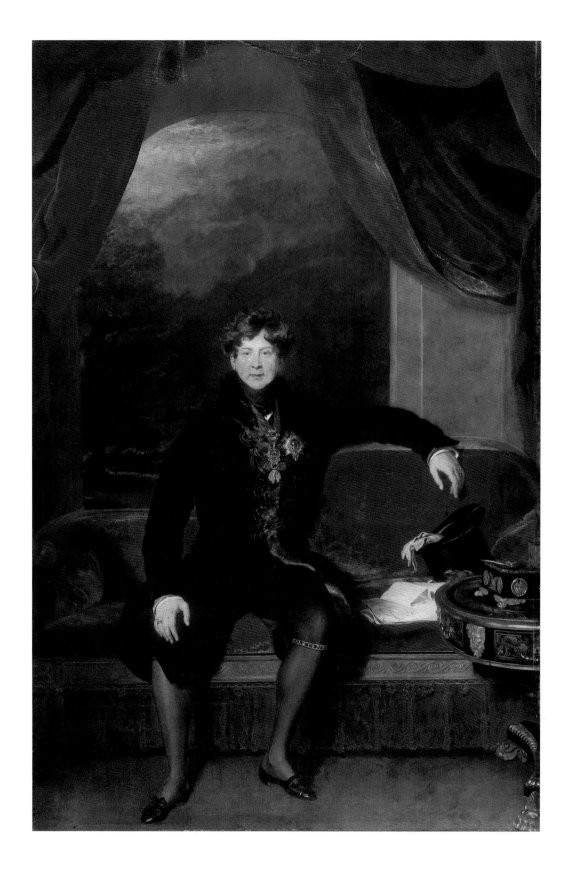

Thomas Lawrence
George IV
England, 19th century (1822)

King George IV

Here you can see another king, this time King of England,
George IV. He ruled nearly 200 years ago. He is sitting quite casually,
looking at us. He has put aside a letter as though we have just walked in
and found him reading it.

Although he is king, he is not wearing a crown or carrying a sceptre like Louis on the last page.

However, we can still tell he is king. There is a **red velvet curtain** behind him
and he has objects which show him to be a member of the ancient Order of
the Garter – a very exclusive group of people made up of the king or queen
and 25 of his or her chosen knights.

Can you find these special objects?

• A brooch in the shape of the Garter Star

• A garter round his leg showing the Garter motto,
HONI SOIT QUI MAL Y PENSE

Did you know?

HONI SOIT QUI MAL Y PENSE means 'shame on him who thinks this evil'. It is said
that King Edward III, who founded the Order, was dancing with Joan, Countess of
Salisbury when her garter fell off. The king picked it up, tied it to his own leg to save
her being embarrassed and said 'Honi soit qui mal y pense'. This sentence became
the Order of the Garter's motto and the blue garter became one of its symbols.

Queen Victoria

Here is a portrait of someone you may already know: Queen Victoria, who ruled Britain from 1837 to 1901. She is shown with many things you would expect to find in the Queen's portrait, such as red velvet, ermine robes, a column in the background, a throne and a crown. In fact, there are two crowns in this painting! Can you find them both?

When this picture was painted, Queen Victoria had been made queen, but she had not yet had the ceremony where she was crowned, called the **Coronation Ceremony.**

The Coronation crown and sceptre are to the left of the painting. They are ready to be put on her head and placed in her hand when the coronation ceremony takes place.

Can you see how the painter has shown this? Queen Victoria is making her way towards the throne, but has not quite reached it. It is as though she is getting ready for this event.

In this painting Victoria is only 19. Look at her face.

How do you think she feels about being Queen?

Queen Victoria made Richard Wallace a 'baronet' for various good deeds that he did for people. This means that Sir Richard must have met her and that he could call himself 'Sir'.

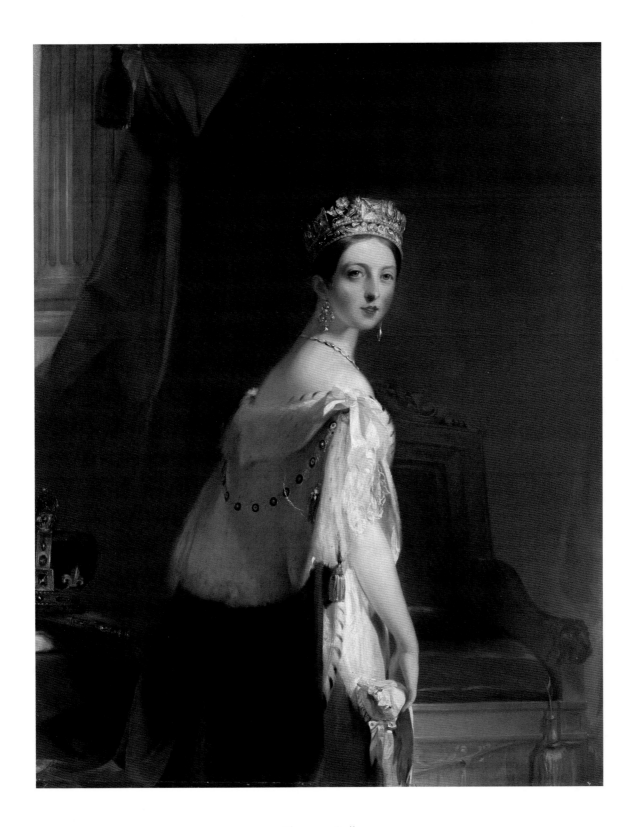

Thomas Sully
Queen Victoria
England, 19th century (1838)

Sir Robert Dudley

Sir Robert Dudley was not a king, but he was very close to Elizabeth I, who ruled during the Tudor times. Many people think that they could have married if he had not been married already. Even so, he was a very important person; he was Master of the Queen's Horse and was given the title 'Earl of Leicester' by the Queen.

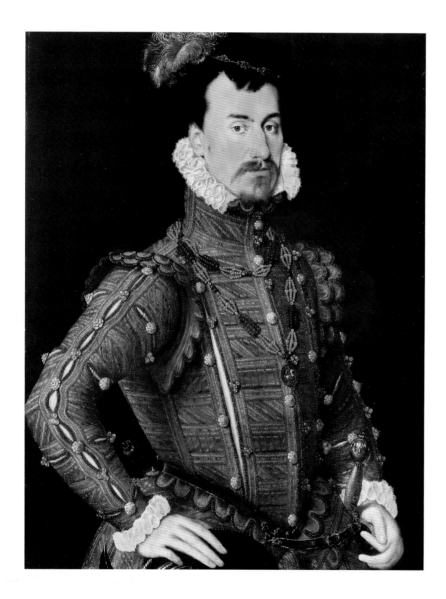

Attributed to Van der Meulen
Robert Dudley, Earl of Leicester
England, 16th century (*c.* 1560–65)

He has no symbols of royalty, but is still shown wearing very fine clothes, made with gold fabric and decorated with pearls. He is also shown with armour. Only the higher ranks of the army would have had fine armour like this. His left hand rests on a sword, his right hand on the top of a helmet.

Did you know?
Sir Robert's first wife died in slightly suspicious circumstances. Some people say he had her killed so that he could marry the Queen.

Like George IV, who you met earlier in this chapter, Sir Robert was a member of the very exclusive Order of the Garter: from his neck hangs a figure of St George on horseback encircled by the Garter motto HONI SOIT QUI MAL Y PENSE.

A Coat of Ten Thousand Nails

This armour is called Chilta Hazar Masha, or 'Coat of ten thousand nails', and is from Rajasthan in western India. Instead of being made of metal, like much armour, it is made of many layers of fabric and studded with small brass nails. Do you think there are 10,000 of them?

Fabric armour helps the wearer to fight whilst still moving about freely, although this suit does have metal plates. Can you see that they protect the heart, stomach, knees and elbows?

Fabric was also very popular in India because of the hot weather. Metal armour could get so hot in the sun that it would burn the wearer!

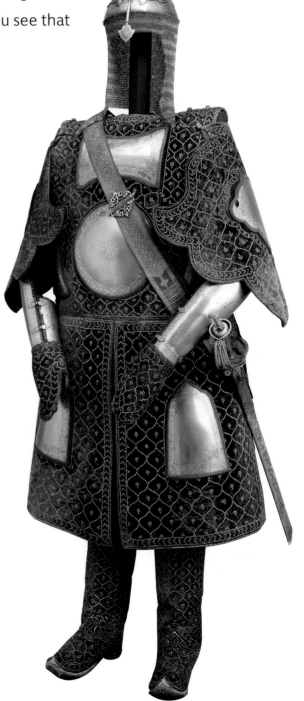

Rajasthan means 'land of the kings'. The Rajput warriors were, and still are, renowned for being incredibly brave. In order to get to warrior heaven, if they did not win the fight, they had to die in battle. To die in bed or to return as the loser from a battle was a huge disgrace. For this reason the Rajputs would ride to battle, but get off their horses to fight so that, if they were injured, their horses could not lead them home to die shamefully.

Fabric and steel armour of a Rajput warrior
Rajasthan, western India
late 18th or early 19th century

Armour for Man and Horse

At the time that this armour was made, most men who fought on the battlefield would have been on foot. Very important members of the army would have fought on horseback and the horses needed to be just as well-protected as the men.

This horse armour is **very rare**. It is made up of large steel plates and mail.

Mail is made of thousands of small rings of iron linked together. It is like metal cloth and is very flexible. **Plate armour** is made up of sheets of metal, carefully shaped with special hammers. Amazingly, this can be made to be rigid when needed, but quite flexible when necessary.

Look at the section which protects the horse's chest. The plates here are rigid, because the armour does not need to move.

Now look at the top of the horse's head and neck.

These plates are much smaller and have been attached with flexible leather straps on the inside. This lets the horse twist his head, move it up and down and from side to side.

Sir Richard loved to collect armour. He didn't wear it though! He put it on display and admired it.

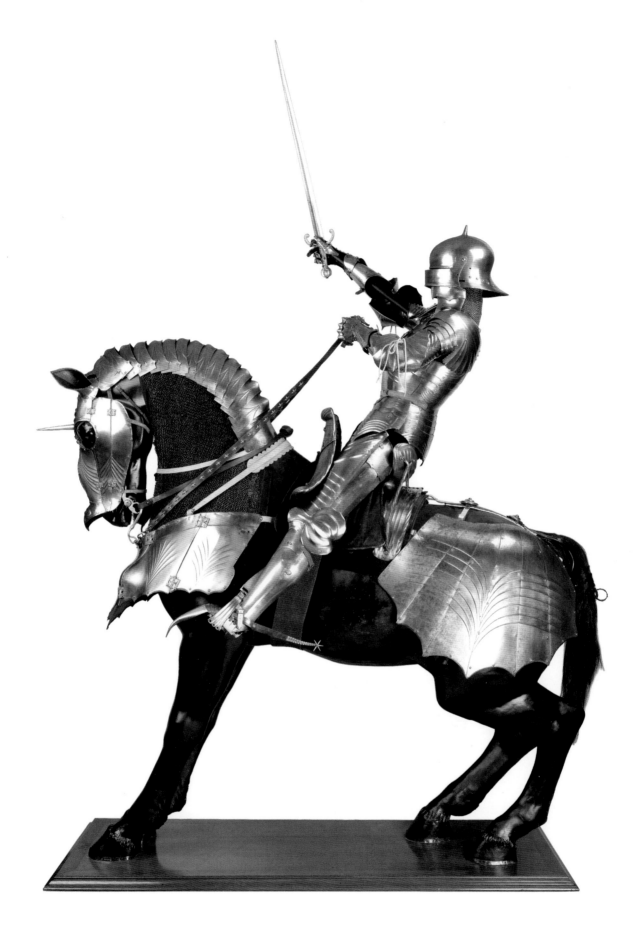

'Gothic' armour for man and horse
Germany
15th century (c. 1480)

Armour for a Tudor Nobleman

This gold-decorated armour was made in Tudor times, when Elizabeth I was Queen of England. Do you think it would be easy to move about in? In fact, it was made for battle, so the wearer needed to be able to fight easily and get away from his enemies. The armourer who made it worked very hard to make sure that the metal plates moved well with the body underneath it.

For example, this sabaton (shoe) is made of small plates of metal, called 'lames', joined together with rivets. This means that when the man moved his foot up and down, the sabaton could move just like the foot inside! Look back on the previous page and compare the feet of the Gothic armour with these later Tudor ones. Look how different they are! These armours were made 100 years apart and show the fashion of shoes at the time. The shape of the sabatons show what shape the shoes were underneath.

Field armour
England
16th century (1587)

Did you know?

Although it looks very heavy, this armour is actually much lighter than the equipment carried by modern soldiers in the British Army.

—— Brave Warriors ——

A Dangerous Sport

This huge and heavy armour was designed for jousting – a sport where two armoured knights on horseback charged each other with lances with the aim of hitting the other knight as hard as possible, in the chest, shield, or head! Sometimes the lances would shatter, at other times one jouster would fall off his horse, and even the horses could be knocked over.

Look closely at this armour and compare it to the armour for a Tudor nobleman on the opposite page. **Can you see how different they are?**

• The jousting armour is thicker, heavier and much more rigid. It is perfect for its purpose.

• The helmet is firmly bolted to the breastplate so that the wearer's neck and head cannot move or be injured by a lance hit.

• There are almost no holes in the helmet. Can you see the narrow slit towards the top of it where the knight would have looked out without being harmed by a lance?

• The armour for the hands has a solid mitten of thick steel to give maximum protection, while the Tudor nobleman's armour has individual fingers so he can move each one separately.

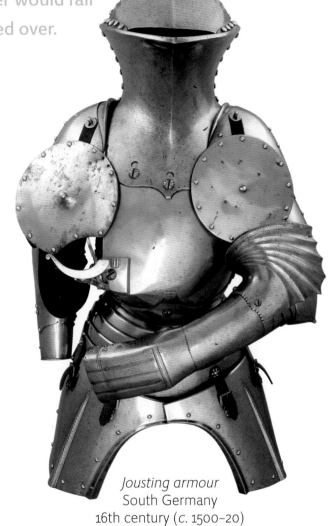

Jousting armour
South Germany
16th century (c. 1500–20)

Did you know?
This armour was made in Germany for a type of joust called the 'Gestech'. This was purely a sport and the jousters did not want to hurt each other too much.

The Swing

This is one of the most famous paintings in Sir Richard Wallace's collection. It shows some rich people having a really good time. It was painted in France about 250 years ago at a time when a particular style of painting was in fashion, called the Rococo. Rococo has wavy, natural shapes, frills and curves; it often shows people having a fun, playful time and can sometimes be a bit naughty too.

Look at the painting. Can you see:

- wavy, natural shapes?
- frills and curves?
- people having fun?
- something a bit naughty happening?

shhhhh

The painter has mainly used **greens** and **blues,** which makes the girl, in her salmon pink dress, stand out amongst the trees and leaves. She is the focus (the most important thing) in the painting.

Everyone seems to be having a great time. The girl is enjoying her swing, while one man pushes her and another gazes up at her. There is even a dog barking excitedly in the bottom right of the painting.

Do you think either man knows the other is there?
We can see everyone and so can the statue on the left.
What is the statue telling us to do?

— Enjoying Yourself —

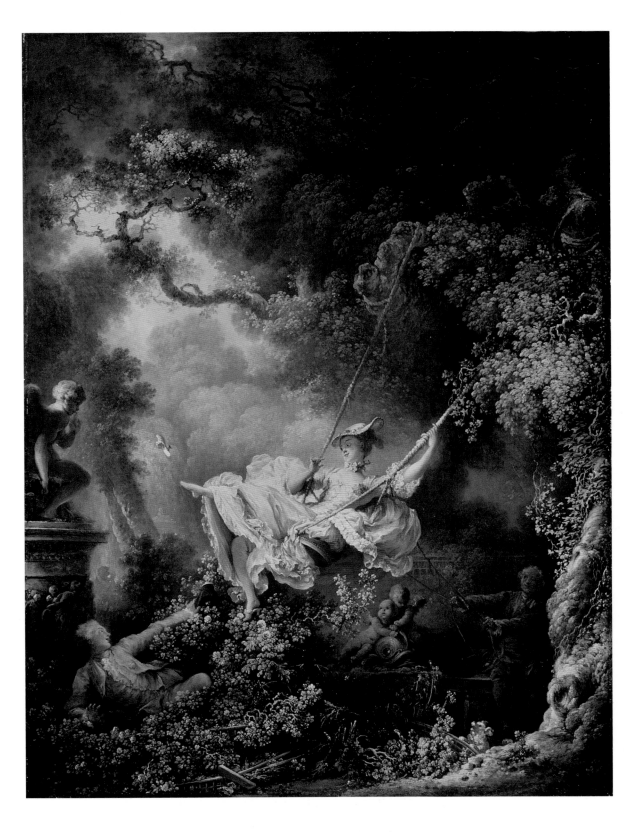

Jean-Honoré Fragonard
The Swing
Paris, 18th century (1767)

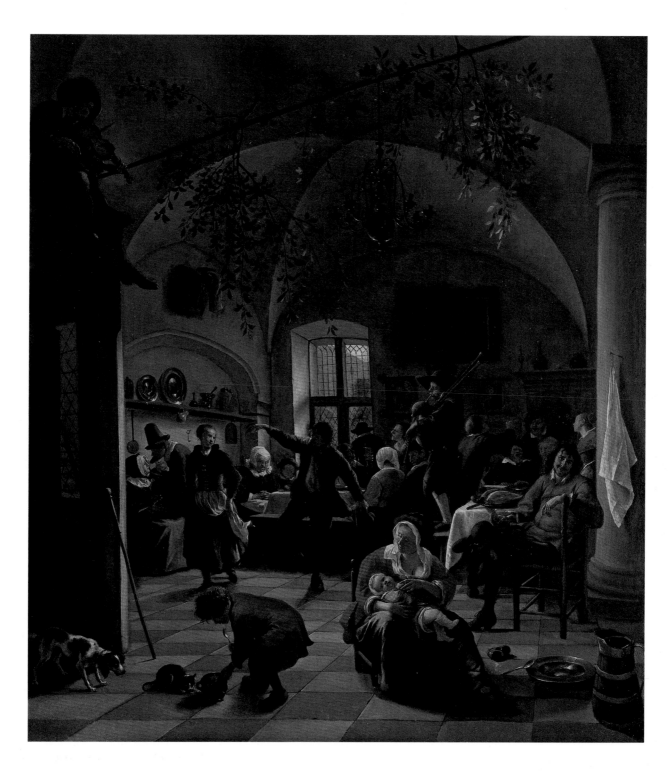

Jan Steen
Merrymaking in a Tavern
Netherlands, 17th century (*c.* 1674)

—— Enjoying Yourself ——

Merrymaking in a Tavern

There is a good feeling to this picture: everyone is just having a great time at the tavern! This painting was made in Holland by an artist called Jan Steen. He owned a tavern, or inn, so he would have been able to see exactly how people behaved before putting them into his paintings.

Can you imagine what it would sound like if you could hear everyone?

There are old people, young people, men, women and children.
See if you can spot the following:

- ♪ people dancing
- ♪ people arguing (the artist is showing us what might happen after too much drinking and dancing!)
- ♪ a woman with her hands together, praying
- ♪ a bagpipe player and a violin player
- ♪ a group of four men drinking and singing

Can you see the walking stick propped up by the door? Some people think this is a type of stick owned by painters and that the artist is reminding us that he is there, that he has made the painting and is in control of the people in it.

Did you know?

Can you see the man sitting on the right who is staring right out at us? He was a famous comic character called '**Mister Pickled Herring**' who appeared in Dutch plays and paintings. Through eating huge numbers of salty pickled herrings, he became very thirsty, which made him drink a lot. He represents **gluttony** (over-eating) or **drunkenness** (drinking too much alcohol).

A Young Archer

This young archer is looking very thoughtful. One hand clutches a bow and he has a bag of arrows over his shoulder. The artist, Flinck, has used very few colours – **black, brown, gold,** cream – to amazing effect. Can you see how the boy's gold earrings, necklace and the metal fastenings on his strap shimmer out in contrast to the darkness of his costume, the background and his skin?

This painting is nearly 400 years old. At this time it was very unusual for a black person to appear as the main subject in a European painting. We really don't know who the boy is and why Flinck has chosen to paint his portrait.

Here are some ideas people have had about the mystery boy:

Is he a huntsman? He has the bow and arrow, but why would a huntsman be wearing gold jewellery and decoration?

Is he a model dressed up? New students in artists' studios were asked to paint studies of models which would help them practise and become more skilful. The contrast the painter needed to create the light and dark would have been quite a test.

Is he a figure from a story? He might be a character from a story or play that was popular at the time, but which is now unknown.

Is he an African archer? In the Old Testament of the Bible, archers from Nubia, now part of Sudan and Ethiopia, are mentioned as being very skilful.

What do you think? You might have a completely different, better, idea!

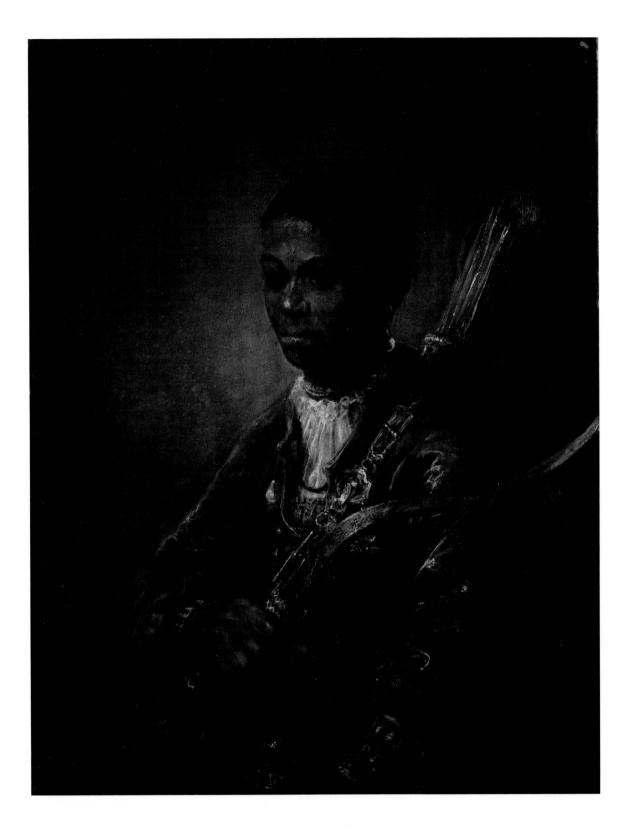

Govaert Flinck
A Young Archer
Netherlands, 17th century (*c.* 1639–40)

Prince Baltasar Carlos

This little child is about 3 years old. Do you think it is a boy or a girl? Look carefully at what the child is wearing and holding. It is a bit strange, isn't it? He or she looks to be wearing a dress, but has a sword and a gorgette (neck armour), which would be more suited to a boy.

In fact this little boy is Prince Baltasar Carlos, son of King Philip IV of Spain, and he lived nearly 400 years ago. In those days it was common for rich little boys to wear dresses until they were 6!

There are a number of ways in which we can tell he is a very important child …

- Fabrics: the **red velvet** curtain and cushion, the **golden thread** in his skirt and jacket, his lace collar and the **pink shimmering sash** all tell us he is a wealthy child.

- Weapons and armour: it is not normal to give a child a sword and armour, but he will be king one day, and will need to defend his country.

- The way he is standing: he stands up very straight and looks out at us confidently as if he knows how important he will become.

- The fact he has had his portrait painted by the greatest Spanish painter of the day: only the very rich could have afforded this.

Sir Richard Wallace had an interesting childhood. From the age of 6 he lived with his father and grandmother in Paris, where he learnt to speak fluent French. This meant that when he was older he spoke English with a slight French accent, even though he was English!

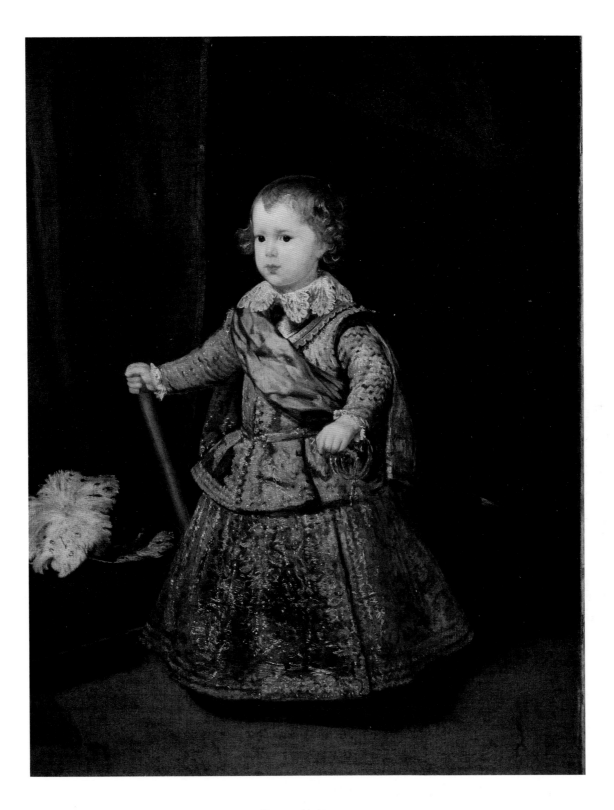

Diego Velázquez
Prince Baltasar Carlos in Silver
Spain, 17th century (1633)

Miss Haverfield

Elizabeth Anne Haverfield looks a bit more relaxed than Prince Baltasar on the last page. She was the daughter of a successful gardener and so had less to worry about than the prince. She has gone out for a walk in the countryside, but she is wearing very fancy clothes.

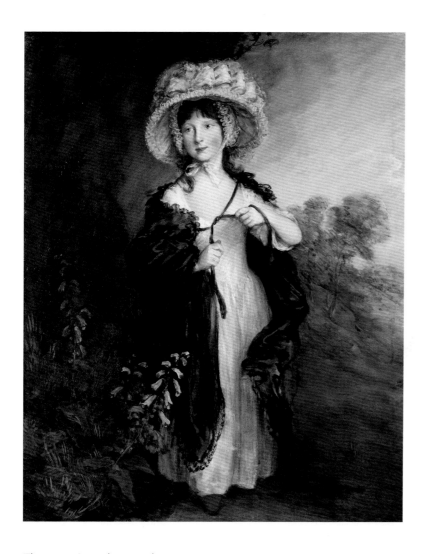

Look at her hat covered with ribbons, her flowing black cloak, and bright red shoes. **Would you wear your best clothes out on a country walk?**

Look at the sky: let's hope it doesn't rain on her lovely hat!

We need to remember that Elizabeth would have known she was having her portrait painted so she would have been wearing her best clothes. **What might you wear to have your portrait painted and how might you stand?**

Thomas Gainsborough
Miss Haverfield
London, 18th century (early 1780s)

The artist has made everything look very natural, as if she has just come round the corner and is tying up her cloak, but he would probably have painted her in his studio and filled in the background later.

> **Did you know?**
> Thomas Gainsborough was quite an unusual painter at this time. Look at the trees on the right and the black of her cloak. They look like they have been quite hurriedly painted. He was known for this 'free' style, but some people complained and said his paintings looked unfinished. **What do you think?**

—— Children and Young People ——

Sssssssslithering Snakes

Look at the animals on this clay dish. There is a snake slithering across it, two black crayfish with pincers scuttling past, a lizard, a green frog and some fish. All of them are in a watery setting along with leaves and shells. Don't they look real! In fact this is not far from the truth, as the man who made the dish used real animals, plants and shells in the process.

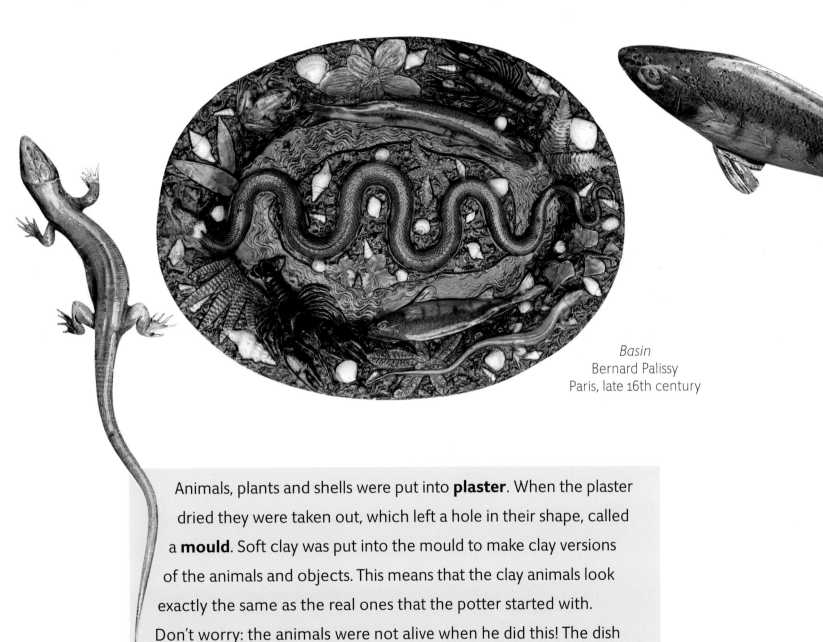

Basin
Bernard Palissy
Paris, late 16th century

Animals, plants and shells were put into **plaster**. When the plaster dried they were taken out, which left a hole in their shape, called a **mould**. Soft clay was put into the mould to make clay versions of the animals and objects. This means that the clay animals look exactly the same as the real ones that the potter started with.

Don't worry: the animals were not alive when he did this! The dish was then painted and glazed several times with **different colours.**

Animals *two by two*

Can you spot all the animals in this picture? They are resting quietly in a tent. There are lots of exotic-looking objects, such as an oriental carpet, pipes and incense, which burns on the left-hand side of the picture, so perhaps the animals are somewhere hot where they need to shelter from the sun.

This is a very gentle work of art.

Each pair of animals nestles together as though they are looking after each other and nearly all of the surfaces are soft fabric or animal fur.

The white mare looks after her brown foal, the baby's neck resting on its mother's tummy as they look out at what is happening outside the tent.

The two greyhounds snuggle together on a comfortable fur rug that looks like you could stroke it.

Monkeys relax on the palm leaves overhead, one wearing an earring and holding an orange.

The scene feels quiet …

Can you imagine what would happen if they were disturbed?

This was probably one of Sir Richard's most expensive purchases, costing nearly £8,000 in 1878, which is over half a million pounds in today's money. Sir Richard must have liked it very much! Do you like it? What do you think made him pay so much money for it?

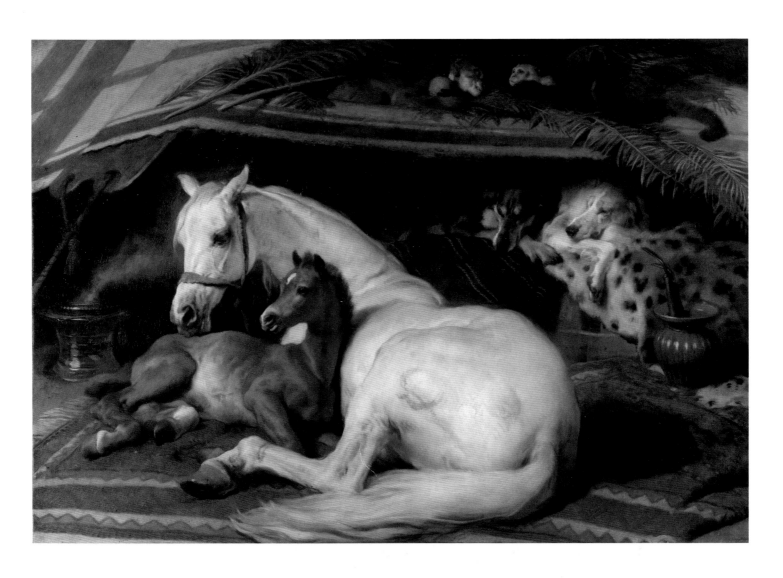

Edwin Landseer
The Arab Tent
19th century (c. 1865–66)

Did you know?

Edwin Landseer was famous for his paintings of animals. He was one of Queen Victoria's favourite painters! The Victorians loved him. **What do you think that tells you about their view of animals?**

Cheeky Monkeys

You will find animals all over the top of this side-table! In the centre there is a cage full of birds, some flying some sitting, while monkeys play and walk tightropes above. This table was made by a famous furniture-maker called André-Charles Boulle.

He was well known for making his furniture out of two materials. One was a gold-coloured material called **brass**. Can you see how the bars of the cage have been made from brass strips? The other was dark-coloured **turtleshell**. Nowadays turtles are protected and people are not allowed to use their shells to make things.

Look carefully at the monkeys. Can you see them doing the following?

- playing the bagpipes
- playing a violin
- walking a tightrope
- sitting on a barrel
- getting very wet!
- holding a glass of wine

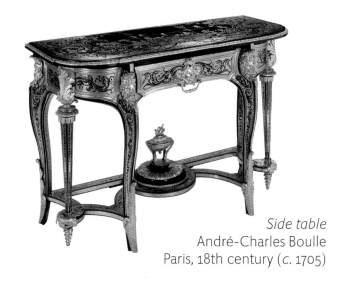

Side table
André-Charles Boulle
Paris, 18th century (*c.* 1705)

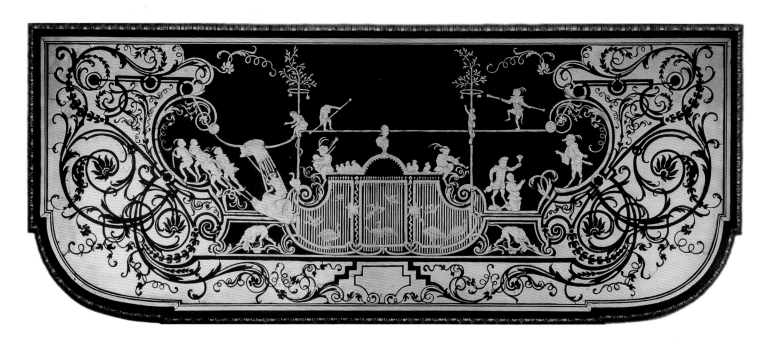

—— Animals ——

A Silver Tiger

This wonderful tiger is made of silver and decorated with gold; it has rubies (red stones) for eyes and an emerald (green stone) in its forehead. It even has a tongue sticking out and tiny teeth in its mouth. This is a bit of a mystery object. Can you guess what it might be?

Ceremonial mace ('sota')
India, late 18th century

In fact it had an important purpose.

It is a ceremonial mace and there are two of them in the Wallace Collection. They would have been carried by two people ahead of an important person so that people knew he was arriving. This particular mace must have announced the arrival of someone very important: can you see how beautifully detailed it is? Can you believe that the silver which is now in this wonderful, highly decorated shape was once in flat sheets?

Did you know?

This tiger is more than 200 years old and comes from India, where tigers were often used to decorate weapons and other objects to show how strong and fierce their owners were.

An Inkstand for a Princess

The story of how to use this wonderful object gives you a sense of what life was like at the royal court in France 250 years ago. It is an inkstand which once belonged to a princess – a daughter of King Louis XV of France called Marie-Adelaïde. You can see King Louis's head in the front at the bottom surrounded by gold leaves.

Marie-Adelaïde would have lifted off the lid of the terrestrial globe (which shows a map of the world), dipped the nib of her pen in the ink and written her letter. Then she would have lifted off the lid of the celestial globe (which shows the stars and signs of the zodiac) and taken out a sand-shaker. She would have dried the ink by shaking sand over it. All that was left to do now was to lift up the crown of France, which contained a bell, to ring it and a servant would come to take the letter away.

Marie-Adelaïde was very lucky; she was a princess, she owned lovely things like this inkstand and she had servants to do things for her! If we want to write to someone these days, what do we do? How often do you write letters to people?

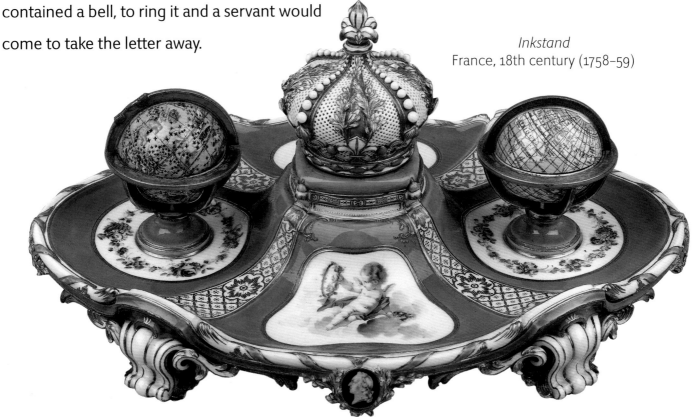

Inkstand
France, 18th century (1758–59)

An Ice-Cream Cooler for an Empress

This ice-cream cooler was once part of a set of 797 objects owned by Empress Catherine the Great of Russia! The set included porcelain for dinner, dessert, tea, coffee, and a big centrepiece to go in the middle of the table to amaze all her guests.

There were 10 ice-cream coolers, like this one, in the service. Can you imagine 10 of these magnificent blue objects on the dinner table with matching plates, cups and saucers? It must have looked very impressive.

Ice-cream cooler
France, 18th century (1778)

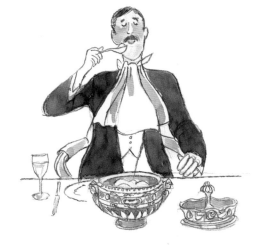

If you look at the object you can see clues as to what it contains. There are icicles dripping from the top of the rim, and there is a frozen fountain which makes a handle so you can take off the lid and get to the ice-cream.

How do you think they kept their ice-cream cold before freezers were invented?
In St Petersburg, the city in Russia where Catherine the Great had her palace, there is a river called the River Neva. It gets very cold there and the river freezes in the winter. Ice would be dug up from the river and packed into ice-houses (small brick buildings) to be stored until it was needed. This cooler has two bowls. The inner one holds the ice-cream and outer one holds the ice so that the inner bowl sits among the ice, keeping the ice-cream cool.

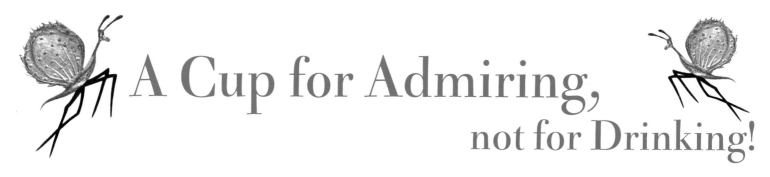

A Cup for Admiring, not for Drinking!

Imagine drinking out of this cup made of silver and decorated with gold! Look carefully and you will see flowers, animals, insects and curls of decoration all over it. Can you find two stags? Towards the top of the cup there is a line of butterflies, balancing on a rail or tightrope.

The red, green, yellow and blue decorations are made with something called enamel, which is a glass-based material. Once the cup and cover had been made by the silversmith, the enameller would have carved out grooves in the silver in the shape of the decoration and filled them in with enamel. The cup and cover was then fired (heated up) in a kiln so that the colours would fix to the silver. Even so, this object was made over 400 years ago and some of the decoration has worn away. Can you see where this has happened on the lid?

This cup looks far too precious to be used. Often objects were put on display in someone's house for visitors to admire. So, rather than actually drinking out of it, the owner was really using the object to show off!

Cup and cover
D. Altenstetter and J. Michael
Germany, early 17th century

Grand Possessions

A Mirror for a Duchess

This mirror was owned by a duchess who lived in France about 300 years ago. The duchess would have looked in this mirror while she carried out her 'toilette', which involved putting on make-up, fixing and powdering a wig and getting ready for the day.

It was a grand event and people would come and watch – the most important people watching from the front, the least important at the back. Just imagine if getting ready for the day took several hours each morning!

The back of this mirror is decorated with plants, mythical creatures and animals. Can you find a large seashell, someone playing the tambourine, a monkey dangling a bone in front of a dog and another dangling a mouse out of reach of a cat? The golden material you can see is brass and the dark material is turtleshell.

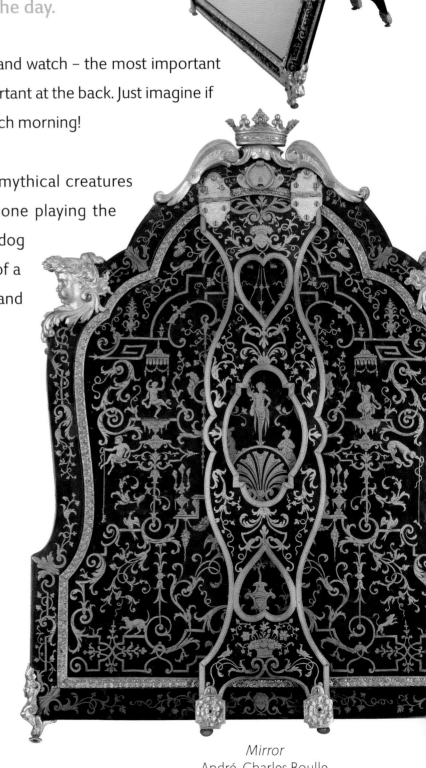

Mirror
André-Charles Boulle
Paris, 18th century (1713)

Did you know?

Can you see the crown on the top of the mirror? This is not part of the original mirror. It was added by Sir Richard Wallace's father, who was a marquess (like a lord). The symbol for a marquess is a coronet or crown so he must have had it added when he bought it. How do you make people know that your things belong to you? Do you personalize them with your initials or symbols that mean something to you?

The Laughing Cavalier

This man looks very pleased with himself. He is called 'The Laughing Cavalier' and although he is one of the most famous works of art in the Wallace Collection, no one knows who he really is.

Can you see some writing in the top right-hand corner? It says 'Aeta[tis] suae 26. Anno 1624', which is Latin and means that he is aged 26 and the year in which he was painted was 1624.

Some people think that he is about to get married and that this portrait may have been made to celebrate the fact. **If you look at his jacket can you see these things?**

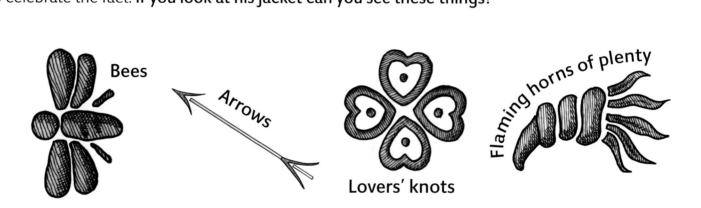

Bees

Arrows

Lovers' knots

Flaming horns of plenty

All of these things can be read as symbols of the pain and pleasure, or sadness and happiness, of love. For example, bees make sweet honey, but they also sting. This is what has made people think it is a marriage portrait. If this were the case, there would have been a portrait of his bride as well, called a 'companion portrait', but, if it existed, no-one knows where it is now.

Did you know?

There are two types of showing off in the portrait. The Laughing Cavalier is a bit of a show-off, but so is the artist, Frans Hals. Hals is showing us all the different types of painting that he can do. The white ruff around the neck is painted in a very free way, while the lace cuff around his wrist is very clear and precise. Look at the way he has painted the face. You can almost touch the human skin, while the black sash is very roughly painted.

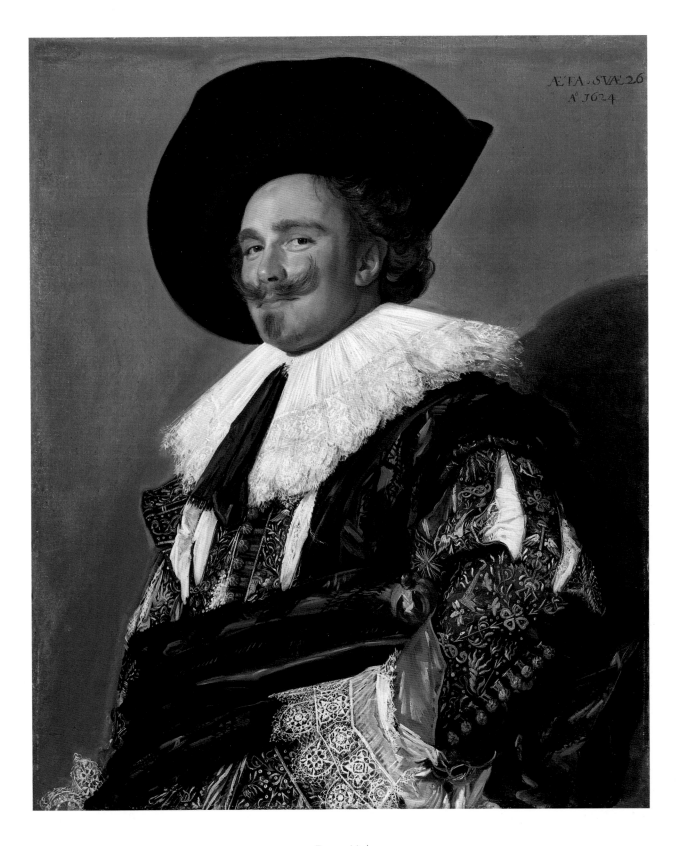

Frans Hals
The Laughing Cavalier
Netherlands, 17th century (1624)

A Golden Snuffbox

Look at this wonderful box made out of solid gold and painted to look like peacock feathers. This object would have been the ultimate show-off item at the French royal court in the 18th century. It was made to hold snuff, a bit like tobacco, which people would sniff as part of an upper-class pastime. There were instructions on how you should take snuff: including sniffing, coughing, sneezing and spitting, which does not sound at all pleasant!

Anyone who was anyone needed to have a gold box in which to hold their snuff and the more beautifully decorated it was, the better.

Incredible craftsmanship went into making a snuffbox. It had to close perfectly and be airtight so that the snuff did not dry out. It also had to be expertly balanced so that when you opened the lid and offered other people a pinch of snuff, the weight of the lid did not cause the box to ₩ob♭le over, which would have been very embarrassing. This box is particularly special because when the lid opened a display of peacock feathers was formed which everyone would see and admire as they took a pinch of snuff.

Snuffbox
Jean Ducrollay
Paris, 18th century
(1743–44)

Here is Sir Richard offering snuff to one of his friends. Fortunately they have not got to the bit yet where they need to 'cough, sneeze and spit'!

A Diamond-studded Elephant Goad

This strangely shaped object is covered with diamonds, rubies and emeralds and looks very impressive. The long section is decorated with jewel-encrusted flowers and at the top of this is an elephant's head. Out of the elephant's mouth come two prongs decorated with yet more jewels and two sharp-teethed animals.

It is called a goad and was made to control an elephant. It would have been used by the elephant driver riding on the neck. He would have hooked the goad behind either the left or right ear of the elephant to tell it which way to turn. The spike is to make it go faster or work harder.

This goad was made for the Maharaja of Jaipur in Rajasthan, India. He was a very important man who would have given it as a gift to one of his top courtiers. This was part of an Indian system of present-giving called 'khillat' which tied the person being given the present to his ruler through giving and receiving in public. The courtier would want to use his gift to show off in public and to show others how important his ruler thought he was.

Elephant goad
India
19th century

PERSEUS AND ANDROMEDA

Can you tell what is happening in this dramatic painting? There is a sea monster, a lady chained to a rock and a man with a shield, sword and a winged helmet. It is showing a myth or story written down in Roman times.

Queen Cassiopeia said that she and her daughter, Andromeda, were more beautiful that the sea-nymphs. This made Neptune, God of the Sea, very angry, so he sent a fierce sea monster to destroy their kingdom. You can see a town in the distance on the right and people standing on the shore looking at what is happening.

The only thing that the King and Queen could do to keep the sea monster away was to sacrifice their daughter Andromeda. Here you can see Andromeda chained up, but thankfully someone has come to save her! The man you can see flying though the air with the help of his winged helmet is Perseus. He killed the sea monster and later he and Andromeda were married.

Did you know?

Artists often change their minds when creating a work of art. First of all Titian put Andromeda on the right and then he moved her to the left. He also had Perseus's arms in a slightly different position and the sea monster came higher out of the water. We can tell this by putting the painting under an x-ray, which reveals the old design. It is fine to change your mind when you make your own artworks.

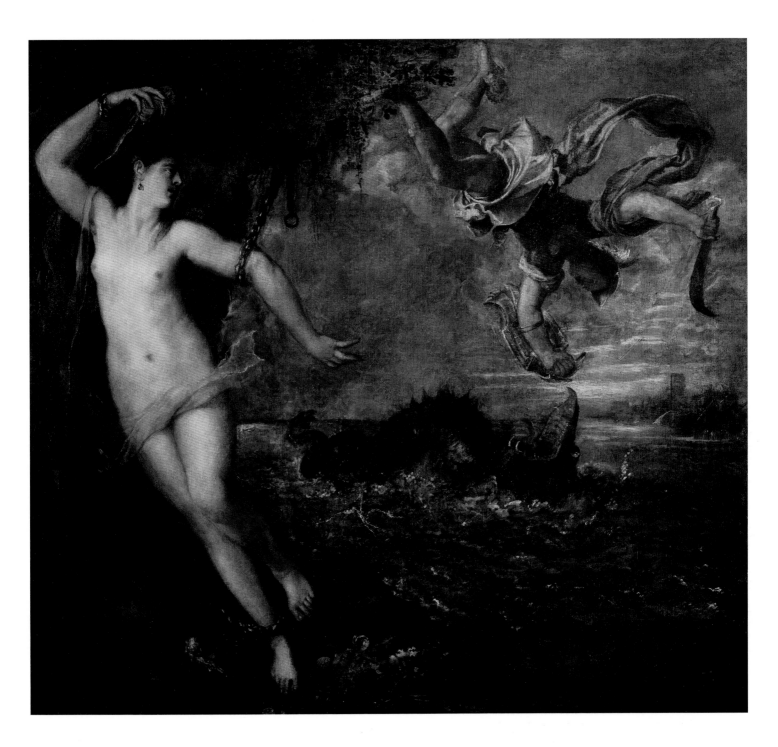

Titian
Perseus and Andromeda
Italy, 16th century (1554–56)

When Sir Richard owned this painting he hung
it in his dressing room, where there was a bath!
Do you think it is a good choice of picture to
have in a bathroom?

St George and the Dragon

This sculpture shows a hero from a story you may already know, the legend of St George and the Dragon. St George is the patron saint of England and the red and white English flag is known as the flag of St George.

Legend has it that a town in Libya, North Africa, was being terrorized by a **dragon** that lived near a lake. The townsfolk fed it a sheep every day to try and stop it attacking them. When this did not work they fed it children from the village. Eventually it was the turn of the king's daughter to be fed to the dragon and he pleaded with his subjects to spare her in return for all his gold and silver, but they would not agree.

His daughter was sent to the dragon, but luckily George was riding by and, making the Christian sign of the cross, he charged at the dragon and managed to wound it. He then tied the princess's girdle (like a belt) around the dragon's neck and led it back into the town where he promised to kill it if the townspeople became Christian. They agreed and the dragon was slain so it could not harm them any more.

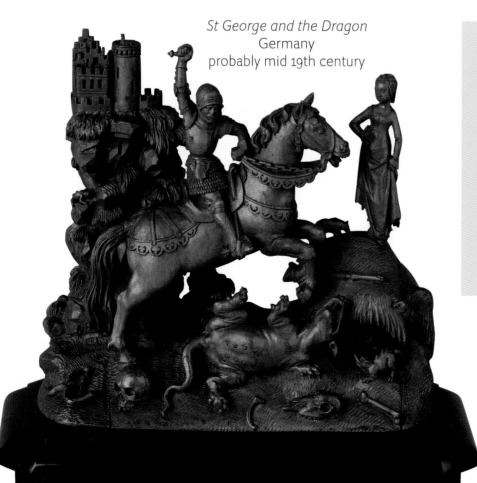

St George and the Dragon
Germany
probably mid 19th century

Can you see:

- a castle in the distance
- the princess standing on a small hill
- St George coming to the rescue
- a cave where the dragon must have been hiding with its babies
- sheep and human skulls of the dragon's last victims

St George has got something missing. The blade of his sword has broken off over time. Let's hope he can still kill the dragon!

Here be Dragons

Can you find a pair of golden dragons hiding on this piece of furniture? You will need to look carefully as it is covered with gold decoration made to look like plants which are climbing and growing all over it. The dragons are also curled like plants so they blend in with the rest of the decoration.

This object is a chest-of-drawers and the dragons are on the top two drawers. Their tails make the handles! **Can you see how the decoration has been very cleverly planned?** It spreads over the top and the bottom drawers so that you can hardly see where each drawer starts. In the middle is a female mask wearing a ruff, earrings and feathers in her hair.

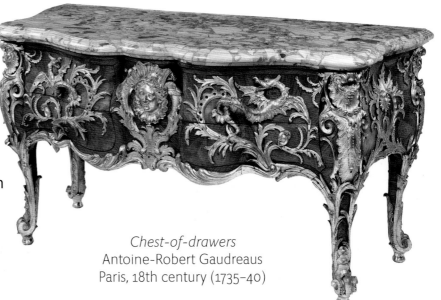

Chest-of-drawers
Antoine-Robert Gaudreaus
Paris, 18th century (1735–40)

Did you know?

At this time in France people were really fascinated by China and the East. It was very fashionable to own Chinese cups, saucers and dishes. Chinese decoration, including dragons, found their way on to all types of objects, which is why there are dragons here.

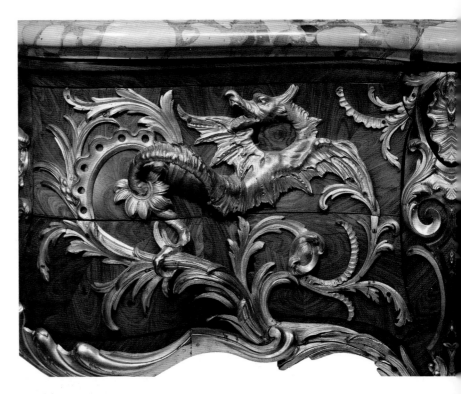

Behind the Scenes at The Wallace Collection

For over 100 years Sir Richard Wallace's home has been a museum open to the public. Many people work at the Collection to make the works of art look their best and to help people find out about them. Here are some of the things that go on 'behind the scenes'…

Displaying

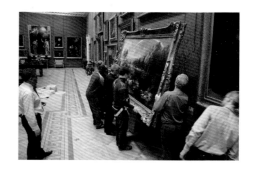

The most important thing that the Museum does is put the works of art on display so that people like you can come in and see them. Here you can see how many people it takes to hang this painting, called *The Rainbow Landscape*, on the wall.

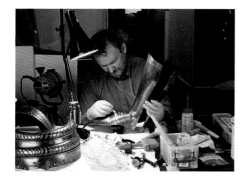

Caring

Very old works of art need to be carefully looked after so that they do not lose colour, get damp or become damaged over time. All of the galleries have special air conditioning so that the temperature is at the right level for the artworks. Metal, such as the armour you see here, needs special attention because if it gets damp it can start rusting. It needs to be regularly polished with a special wax to keep it looking its best.

Documenting

Art objects need to be carefully recorded. Staff study them so that they know as much about them as possible and then record this information along with a photograph of the object. The Wallace Collection is photographing all of its objects so that we have a good record of everything and so that these images can be used in books, like this one, and on the internet.

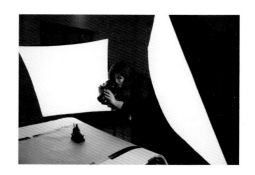

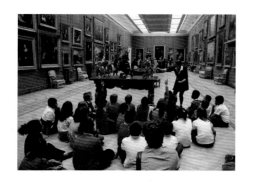

Interpreting

There is no use knowing all about an object if you are not going to tell anyone about it! We welcome thousands of people a year through education activities where people find out more and share their own ideas about the Collection. Adults, children, school groups and community groups can visit this treasure-house for free, take part in activities led by educators and artists and hopefully learn something new in this beautiful setting.

Communicating

We want everyone to know about all of the treasures in the Collection so that they can come and see them. After all, they belong to everyone! In order that people find out about us we produce posters, leaflets and a website where people can learn about us. We hope you will tell your friends about us too now you have read this book!

Research

Experts often work at museums finding out about works of art and writing articles about their discoveries. This involves looking carefully at art objects, studying hard to learn more about them and their makers, talking to other experts and spreading their ideas across the world.

We hope Sir Richard would have approved of the Wallace Collection today.

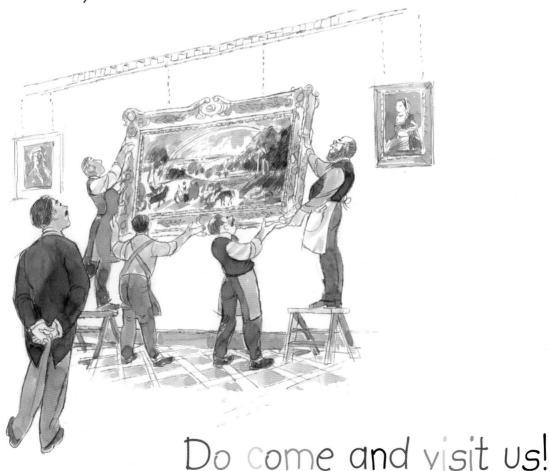

Do come and visit us!

Meet Sir Richard Wallace and his Family!

SIR RICHARD'S GREAT, GREAT GRANDFATHER

Francis Seymour-Conway
1719–1794
1st Marquess of Hertford

m

Lady Isabella Fitzroy
1726–1782

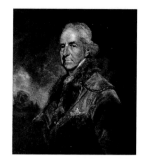

Descended from the brother of Jane Seymour, one of the wives of King Henry VIII.

SIR RICHARD'S GREAT GRANDFATHER

Francis Ingram Seymour-Conway
1743–1822
2nd Marquess of Hertford

m

Isabella Anne Ingram Shepherd
1760–1834

The Prince of Wales (later King George IV) fell in love with the 2nd Marquess's wife. There was lots of gossip about them!

SIR RICHARD'S GRANDFATHER

Francis Charles Seymour-Conway
1777–1842
3rd Marquess of Hertford

m

Maria Fagnani
1771–1856

Married the daughter of an Italian dancer. This match was not really approved of by his family, but made him lots of money as two men left her their fortunes in their wills!

SIR RICHARD'S FATHER

Richard Seymour-Conway
1800-1870
4th Marquess of Hertford

x

Mrs Agnes Jackson
c. 1789–1864

Said 'my collection is the result of my life', was one of the greatest ever art collectors and one of the richest men in Europe. Brought Sir Richard Wallace up, but did not tell him he was his father while he was alive.

SIR RICHARD

Sir Richard Wallace
1818–1890
Baronet

m

Amélie-Julie-Charlotte Castelnau 1819–1897
Lady Wallace

The illegitimate son of the 4th Marquess. Did not know who his father was until after his father's death when he inherited his amazing art collection. His son, Edmond Richard Wallace, died before Sir Richard so could not inherit the Collection.

Met Richard Wallace around 1840, but did not marry him until 1871 after the death of Sir Richard's father, who did not approve of her. Left the Wallace Collection to the British nation in 1897, the most important gift of art treasures ever left to the nation.

Object List (in order of appearance)

KINGS, QUEENS AND IMPORTANT PEOPLE

Studio of Louis-Michel Van Loo, *Louis XV*
Paris, 18th century (*c.* 1760)
Oil on canvas, 136.6 x 104 cm
P477

Thomas Lawrence, *George IV*
England, 19th century (1822)
Oil on canvas, 270.5 x 179 cm
P559

Thomas Sully, *Queen Victoria*
England, 19th century (1838)
Oil on canvas, 142.5 x 112.5 cm
P564

Attributed to Van der Meulen
Robert Dudley, Earl of Leicester
England, 16th century (*c.* 1560–65)
Oil on oak panel, 91.2 x 71 cm
P534

BRAVE WARRIORS

Fabric and steel armour of a Rajput warrior
Rajasthan, western India,
late 18th or early 19th century
A1828

'Gothic' armour for man and horse
Germany, 15th century (*c.* 1480)
Iron, steel, brass and leather
wt 27.16kg (man), 30.07kg (horse)
A21

Field armour
England, 16th century (1587)
Steel, leather, brass and gold, wt 32.03 kg
A62

ENJOYING YOURSELF

Jousting armour
South Germany, 16th century (*c.* 1500–20)
Steel, leather and brass, wt 40.91 kg
A23

Jean-Honoré Fragonard, *The Swing*
Paris, 18th century (1767)
Oil on canvas, 81 x 64.2 cm
P430

Jan Steen, *Merrymaking in a Tavern*
Netherlands, 17th century (*c.* 1674)
Oil on canvas, 73.3 x 65.9 cm
P158

CHILDREN AND YOUNG PEOPLE

Govaert Flinck, *A Young Archer*
Netherlands, 17th century (*c.* 1639–40)
Oil on oak panel, 67.7 x 52 cm
P238

Diego Velázquez
Prince Baltasar Carlos in Silver
Spain, 17th century (1633)
Oil on canvas, 117.8 x 95.9 cm
P12

Thomas Gainsborough, *Miss Haverfield*
London, 18th century (early 1780s)
Oil on canvas, 126.2 x 101 cm
P44

ANIMALS

Basin, Bernard Palissy or a follower
Paris, late 16th century
Painted and lead-glaze earthenware
L 49.3 x W 37.1 cm
C174

Edwin Landseer, *The Arab Tent*
London, 19th century (*c.* 1865–66)
Oil on canvas, 153.6 x 226.4 cm
P376

Side table, André-Charles Boulle
Paris, 18th century (*c.* 1705)
Oak, pinewood, walnut, brass and
turtleshell, H 78.5 x W 120 x D 50.5 cm
F425

Ceremonial mace ('sota')
India, late 18th century
Silver, gold and precious stones
L 77.3 cm, wt 2.77 kg
OA1760

GRAND POSSESSIONS

Inkstand
France, 18th century (1758–59)
Sèvres porcelain manufactory
H 17 x L 38 x W 27.1 cm
C488

Ice-cream cooler
France, 18th century (1778)
Sèvres porcelain manufactory
H 23.7 x W 26.2 cm
C478

Cup and cover
David Altenstetter and Jeremias Michael
Germany, early 17th century
Gilded and enamelled silver, H 22.2 cm
XIIA112B

Mirror, André-Charles Boulle
Paris, 18th century (1713)
Oak, ebony, brass and turtleshell
H 73 x W56 cm
F60

SHOWING OFF

Frans Hals, *The Laughing Cavalier*
Netherlands, 17th century (1624)
Oil on canvas, 83 x 67.3 cm
P84

Snuffbox, Jean Ducrollay
Paris, 18th century (1743–44)
Gold and enamel, H 3.2 x L 7.6 x D 5.8 cm
G4

Elephant goad
India, 19th century
Gold, steel, enamel and precious stones
L 46.4 cm
OA1384

HEROES AND MONSTERS

Titian, *Perseus and Andromeda*
Italy, 16th century (1554–56)
Oil on canvas, 175/173 x 189.5/186.8 cm
P11

St George and the Dragon
Germany, probably mid 19th century
Boxwood, H 9.6 x D 10.2 cm
S278

Chest-of-drawers
Antoine-Robert Gaudreaus
Paris, 18th century (1735–40)
Wood and gilt-bronze
H 93.3 x W 179.3 x D 81.5 cm
F85

ACKNOWLEDGEMENTS

With great thanks to the following people who helped with the production of this book:

The Hon Elizabeth Cayzer
Dame Rosalind Savill, Director of the Wallace Collection

WALLACE COLLECTION STAFF
Tobias Capwell, Nell Carrington, Stephen Duffy, Robert Elgood, Suzanne Higgott,
Edwina Mileham, Cassandra Parsons, Christoph Vogtherr, Jeremy Warren

ILLUSTRATORS
Robin Ollington, Albany Wiseman

DESIGNER
Laura Parker

First published 2009; this edition 2012
© 2012 The Wallace Collection
Texts © 2012 the author

ISBN 978 0 900785 90 0

British Library Cataloguing in Publication Data. A catalogue record of this book is available from the British Library

Produced and distributed by Paul Holberton publishing
89 Borough High Street, London, SE1 1NL
www.paul-holberton.net

Illustrations by Robin Ollington and Albany Wiseman
Design by Laura Parker
Printed by E-Graphic in Verona, Italy